HARROGATE
HISTORY TOUR

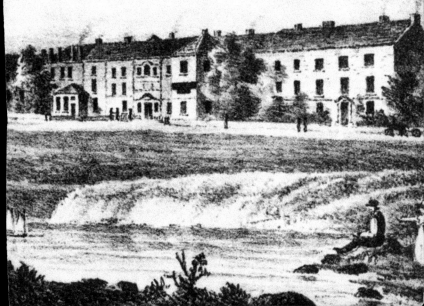

First published 2016

Amberley Publishing
The Hill, Stroud,
Gloucestershire, GL5 4EP
www.amberley-books.com

Copyright © Paul Chrystal, 2016
Map contains Ordnance Survey data
© Crown copyright and database right
[2016]

The right of Paul Chrystal to be
identified as the Author of this work
has been asserted in accordance with
the Copyrights, Designs and Patents
Act 1988.

ISBN 978 1 4456 6608 2 (print)
ISBN 978 1 4456 6609 9 (ebook)

British Library Cataloguing in
Publication Data.
A catalogue record for this book is
available from the British Library.

Origination by Amberley Publishing.
Printed in Great Britain.

ACKNOWLEDGEMENTS

Thanks go to Sarah McKee, Community Projects Officer, Bettys & Taylors of Harrogate; Mr V. Johnson for permission to use the old images of Hotel Majestic; Lynn Mee and the staff at the Turkish Baths for allowing access and photography; Robert Ogden of Ogden of Harrogate Ltd; Ros Watson and the staff at the Royal Pump Room Museum; and the staff at the Royal Baths Chinese Restaurant.

By the same author:
Harrogate Pubs [including Knaresborough]
Secret Harrogate
Secret Knaresborough
Knaresborough Through Time
The Vale of York Through Time
York in the 1970s

INTRODUCTION

Harrogate is, by any measure, a fine and elegant town. The buildings that stand as testimony to its heritage as a leading European spa town – its grand hotels, the abundance of flowers every spring, the magnificent Stray, the equally magnificent Valley Gardens and 'institutions' like Bettys and Ogden's – all combine to produce a place that exudes style and breathes history, a place where it is simply good to be. Not that this has made it superior or arrogant in any way – far from it. The town has always enjoyed a reputation for being more down to earth than other spa towns such as Bath or Cheltenham.

To a greater or lesser extent, all this is revealed in *Harrogate History Tour*: the book provides an intriguing glimpse of how Harrogate began and the reader will finish the book with a good understanding of Harrogate's development from two distinct villages to a pre-eminent spa town, offering more variety in terms of treatments and waters than anywhere else in the world.

A 1930s guide to Harrogate summed up the town as 'the Mecca of the ailing, the playground of the robust' and in that motto lies the essence of the place. The Tewit and St John's Wells, the Royal Pump Room, the Royal Baths and the Stray give us the therapeutic aspect; the Royal Hall, Hotel Majestic and other hotels, Winter Gardens and Harrogate Theatre provided the accommodation and nightlife.

The marvellous conservation and restoration work has kept history vibrant and alive here.

A rich cast of characters made the place what it is and what it was. The list of visitors is extensive, with authors Defoe, Byron, Smollet, Dickens and Agatha Christie making cameo appearances, with Elgar, Britten, Parry, Bax and the Beatles, to name but a few. Add to this a walking Debrett's guide of British aristocracy and European royalty, and the book comes alive with literary, musical and historical anecdotes matched only by the stories that local firms such as Bettys & Taylors, Farrah's and Ogden's live on to tell us.

Paul Chrystal, August 2016

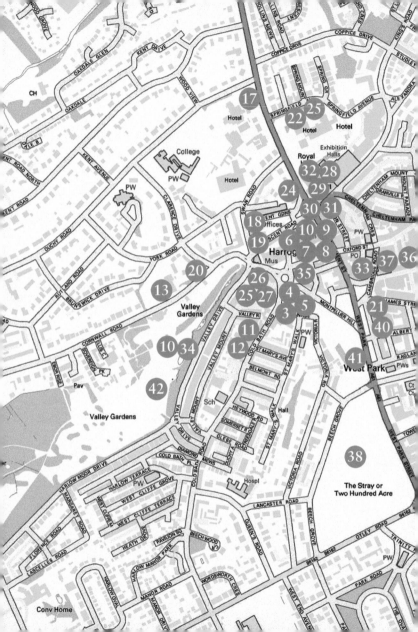

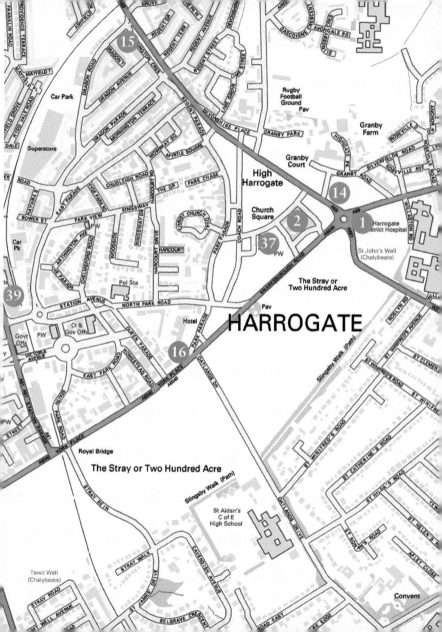

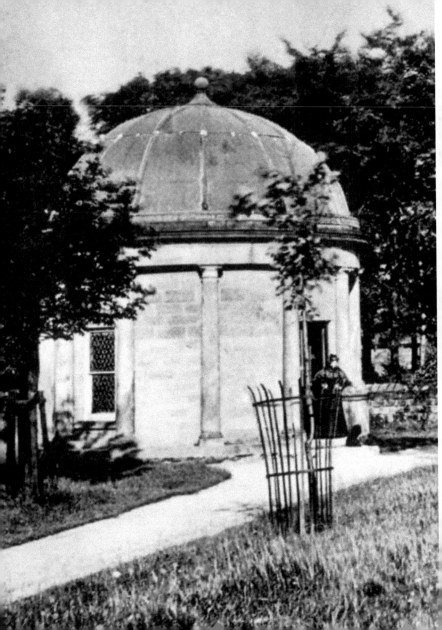

1. THE TEWIT WELL

William Slingsby's discovery of the strange, rusty-looking waters of the Iron Spring, or Tuewhit – later Tewit – Well in 1571 marked the genesis of Harrogate as a world-famous spa town. Dr Edmund Deane, a prominent York physician, in his 1626 work *Spadacrene Anglica* or *The English Spaw Fountaine*, tells us that Slingsby brought the new-found asset to the attention of Elizabeth I's physician, Dr Timothy Bright. Bright, on drinking the water, 'found it in all things to agree with those at the Spaw' – namely, the two famous medicinal springs of Sauvenière and Pouhon at Spa in Belgium, which happened at the time to be so much of a den of Catholicism that the English Crown was trying to deter its subjects from visiting there. Finding a spa in Harrogate (the first English town to be named a spa) was a godsend, and from then on Harrogate's reputation was assured. Another link, albeit tenuous, between Spa and Harrogate is that Agatha Christie's fictional detective Hercule Poirot was born in Spa and stayed in the Swan Hotel. The Well inherited the 1808 Tuscan-columned temple, originally at the Royal Pump Room and designed by Thomas Chippendale; it was closed in 1971, 400 years after its opening.

2. ST JOHN'S WELL

St John's, or the 'Sweet Spaw', was discovered in 1631 by Michael Stanhope and was soon joined by a 'necessary house' (toilets), thus providing a very early example of a roadside service station. The medical profession generally, and Stanhope in particular in his 1632 *Cures Without Care,* promoted the benefits of the waters, and claims grew that they helped in the treatment of indigestion, flatulence, 'hysterical affections' and alcoholism. For many years it was the most popular of Harrogate's chalybeate wells. The first pump room here was built in 1788 by local Alexander Wedderburn. Not everyone, though, was happy: this from Dr Short in his 1740 *History of Mineral Waters* – 'the rendezvous of wantonness and not seldom mad frolics ... luxury, intemperance, unseasonable hours, idleness, gratification of taste are becoming so fashionable ... now it's become so chargeable.' Whether he was genuinely concerned that his colleagues' good work was being undone by the apparent decadence, or whether he was just moaning about the prices, remains unclear. The well closed in 1973.

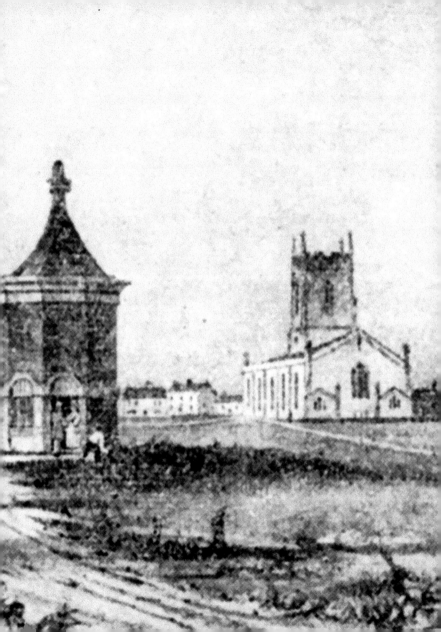

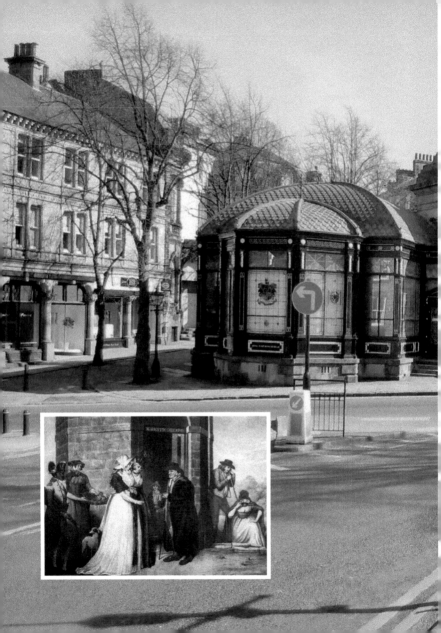

3. THE CHALYBEATE WELL AT HARROGATE

Featured in a painting by John Raphael Smith (1796), which is on display in the Mercer Art Gallery and shows the Sweet Well with people coming to take the waters, the Royal Pump Room dates from 1842. It was built under the auspices of the newly formed Improvement Commissioners, who were empowered to provide a suitable building to house the Sulphur Well – the world's strongest sulphur well. The original cover was moved to the Tewit Well, where it survives today. The Pump Room was designed by Isaac Shutt and cost £3,000. Stanhope was the first to differentiate between the clientele at the different wells, describing those here as 'the vulgar sort' and questioned the standards of hygiene when 'it was open for the promiscuous of all sorts ... so that the poor Lazar [the leprous] impotent people do dayly environ it, whose putrid rags lie scattered ... it is to be doubted whether they do wash their soares and cleanse their besmirched clouts, though unseen, where diverse persons after dippe their cups and drinke.' It seems that leprosy patients were tolerated when the well was in the open but when it became closed in, they were no longer welcome.

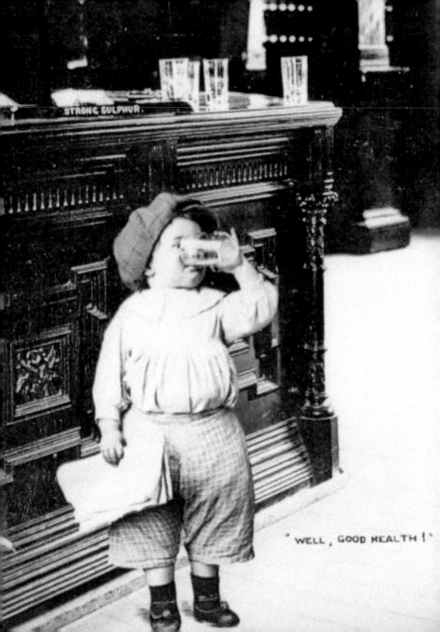

"WELL, GOOD HEALTH!"

This annexe to the Royal Pump Room was formally opened by the Rt Hon the Lord Mayor of London (Sir David Burnett Bart) on 7th June 1913. Councillor J.S. Rowntree M.A. Councillor J. Sheffield Mayor, Chairman, Wells & Baths Committee

Domine Dirige Nos

4. 'WELL GOOD HEALTH' AT THE 'STINCKING SPAW'

The Latin inscription on the Pump Room is *Arx celebris fontibus*, the old town motto at its 1884 Charter of Incorporation, loosely rendered as 'the town famous for its springs'. Betty Lupton, Old Betty, Queen of the Well, served the 'strong sulphur' water at the Old Sulphur Well for over sixty years before her death in 1843. One Dr Thorp analysed the waters here, 'Proven to be beneficial in most forms of Indigestion; Constipation, Flatulence and Acidity. For all cases of functional disorders of the liver. For stimulating the action of the kidneys and in all forms of Chronic Skin Diseases. To be drunk warm or cold. Dosage between 10–24 ounces to be taken early in the morning.'

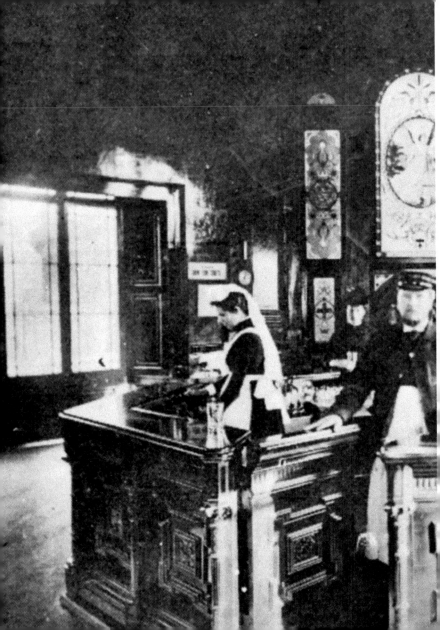

5. INSIDE THE PUMP ROOM

Attendants at the entrance to the Pump Room. The author of the 1813 *Guide to All the Watering and Sea-Bathing Places* was less than complimentary: 'Harrowgate water tastes like rotten eggs and gunpowder; and though it is probable that no person ever made a trial of such a mixture, the idea it conveys is not inapplicable ... While some places are visited because they are fashionable, and others on account of the beauty of their scenery, Harrowgate possesses neither of those attractions in a superior degree, and therefore is chiefly resorted to by the valetudinary, who frequently quaff health from its springs, else we cannot suppose that upwards of two thousand persons annually visit this sequestered spot ... it lies ... on a dreary common'. How things were to change.

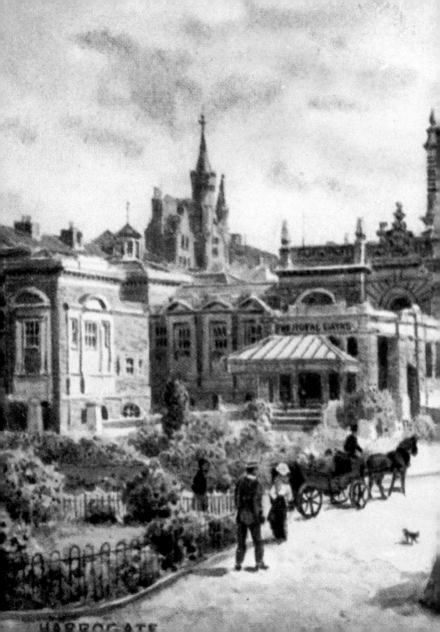

THE ROYAL BATHS

HARROGATE

6. THE ROYAL BATHS

Built by Baggalay & Bristowe in 1897 on the site of Oddy's 1819 Saline Chalybeate Pump Room, the magnificent Royal Baths opened on 3 July 1897 and went on to provide some of the most advanced hydrotherapy treatments in the world. The baths gained a new wing in 1898 for the Peat and Plombieres Baths – the latter for the very popular 'Plombieres Two-way System' or 'Harrogate Intestinal Lavage System', a colonic irrigation treatment that could result in the loss of half a stone in weight. They were extended in 1909 and 1911, and again in 1939 to include a new treatment wing, panelled lounge hall and the open-air fountain court. Used by the National Health Service from the late 1940s until 1968, they were then given over to private patients for a short period. By 1969, only the Turkish Sauna suite was in operation, but it remains one of the most beautiful of England's last remaining Victorian baths.

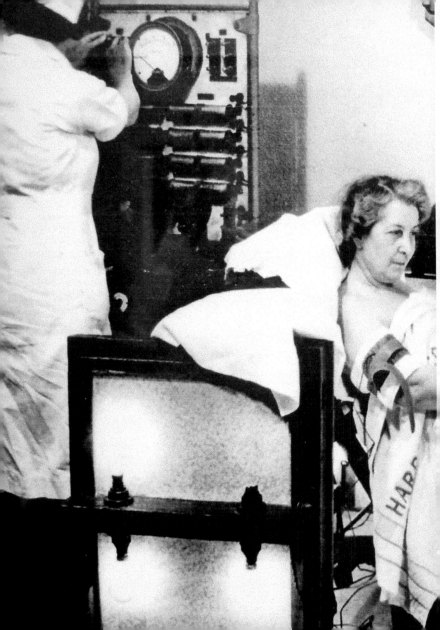

7. THE PEAT BATH

Peat baths were also very popular in the Royal Baths – there were four of them: Mineral Peat Bath, the Brine Bath, the Electric Bath and the Ordinary Peat Bath. The minerals for these were brought in from the North York Moors. The baths themselves were made of Burma teak and took one week to make. Peat baths were efficacious in cases of rheumatism, lumbago, sciatica and the like.

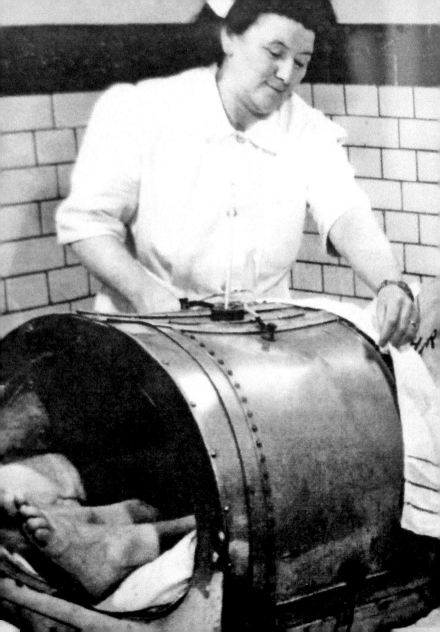

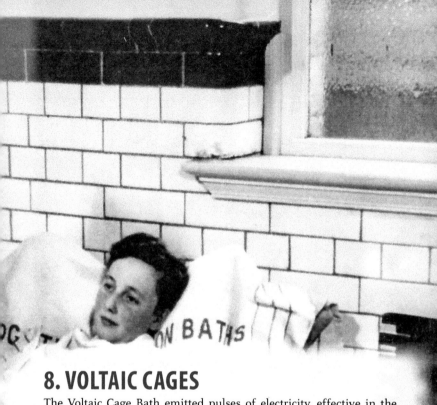

8. VOLTAIC CAGES

The Voltaic Cage Bath emitted pulses of electricity, effective in the treatment of patients with polio and MS. The uniform of the female attendants was a long, bottle-green skirt, white blouse, large apron and a cap. Men wore a collar and tie and a jacket, which must have been insufferable at these temperatures. The laconium was heated to 79 degrees Fahrenheit and the caldarium a cool (by comparison) 55 degrees. One of the attendants' crucial jobs was to wipe the brows of clients, lest the steaming water scald their eyes. There were twenty female attendants and three male – as women were unable to undress themselves (the buttons on their dresses being at the back), each lady needed her own attendant.

9. NEW VICTORIA BATHS

Built at the behest of the Harrogate Improvement Commissioners in 1871 on the site of the 1834 Old Victoria Baths, they were originally called the John Williams' Baths, after the owner. The Commissioners used the upper floor in the central block as offices for a while. They were succeeded by the council after 1884 and, when the baths closed in the 1920s, the building was later converted into a town hall, the council chamber of which is today virtually in the same place as it was for the commissioners.

10. THE MAGNESIA PUMP ROOM

This Gothic-style building was constructed by the Improvement Commissioners in 1858 in Bogs Field, before it was incorporated into the Valley Gardens. Popular on account of its milder waters (today it would be branded 'Sulfur Lite'), the site is now occupied by a cafeteria. The Royal Bath Hospital can be seen in the background. By the mid-nineteenth century, the waters of Low Harrogate had become more popular than their High Harrogate neighbours', and this led to the plethora of baths here at the time. This was all very different from the early days when, as Deane told us in 1626, 'the vulgar sort drinke these waters to expelle reefe and felon; yea many who are much troubled with itches, scabs, morphews, ring-worme, and the like are soone holpen'. Defoe in his *Tour Through the Whole Island of Great Britain* saw it differently in 1717: 'We were surprised to find a great deal of good company here ... though this seems to be the most desolate and out-of-the-world place, and that men would only retire to it for religious mortifications, and to hate the world, but we found it quite otherwise.' The Magnesia Well was closed in 1973.

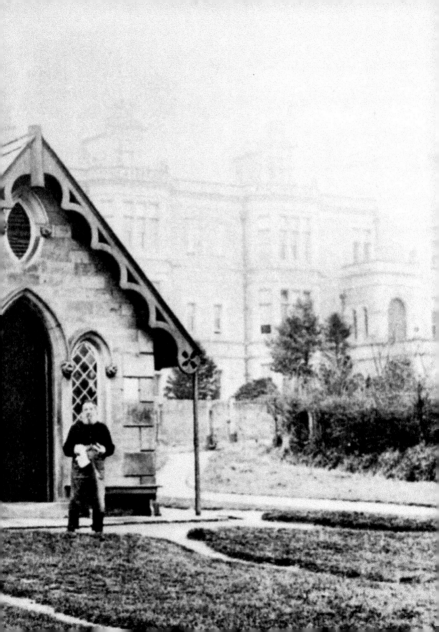

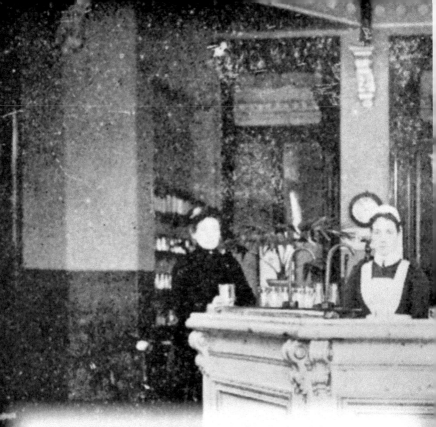

11. SERVING THE WATERS AT THE MONTPELLIER

Here is a wonderful picture of the Montpellier water servers in the late nineteenth century. The baths were established in 1835 by Joseph Thackwray – who also owned Montpellier gardens and the Crown Hotel – 6,000 baths were taken here in the 1839 season. For many years, Montpellier's were considered the best baths in town; they specialised in needle shower and douche baths and invalid Sitz baths.

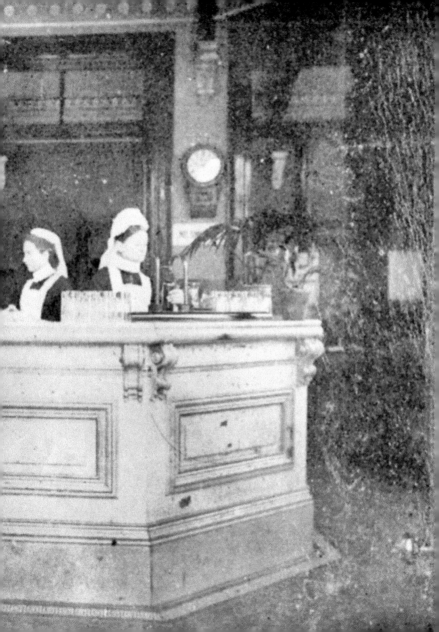

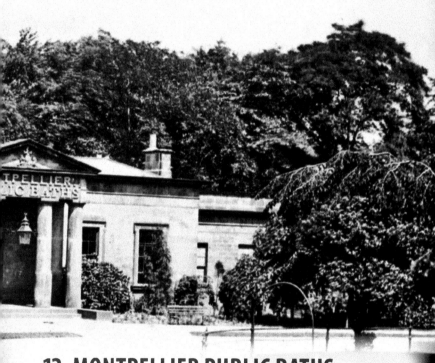

12. MONTPELLIER PUBLIC BATHS

Six new wells, including the famous Kissingen Well, were discovered when the foundations were being dug, no doubt to the delight of Thackwray. The small octagonal building that survives was originally a gatehouse and ticket office for the hotel's gardens.

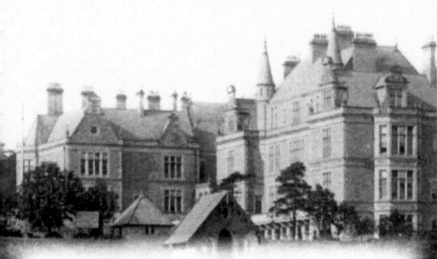

13. ROYAL BATH HOSPITAL

This 1892 photograph shows the 150-bed Royal Bath Hospital and Rawson Convalescent home in Cornwall Road. It was built in 1889 at a cost of £50,000, and was on the site of the original forty-bed Bath Hospital, which dated from 1824. The purpose of the Royal Bath was to cater for poorer patients who could not afford to pay for the typical Harrogate treatments, and who lived at least 3 miles out of town. In 1931, 1,700 cases from all over the UK were treated. Originally, no waters were available on-site and patients had to go to places like the Royal Baths to take the cure. The hospital closed in 1994, but not before it had won a reputation as a centre of excellence for the treatment of rheumatoid diseases and as a leading hospital for hydropathic treatments. It is now the Sovereign Court residential development.

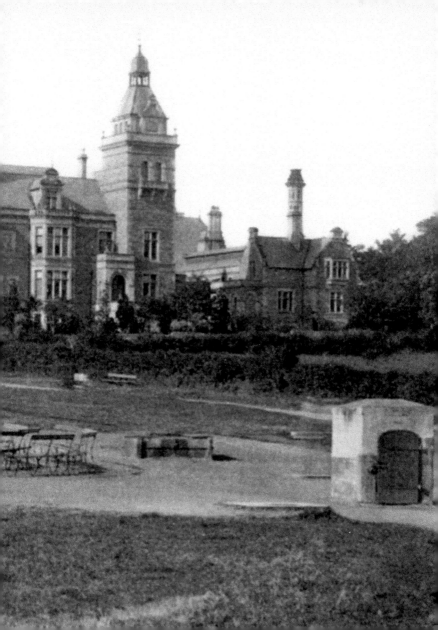

14. THE GRANBY HOTEL

Harrogate's reputation for fine hotels grew from a need to accommodate the increasing numbers of visitors to the spa town. Former names of the Granby include the Sinking Ship (a reference to the defeat of the Spanish Armada) and the Royal Oak. It was the Royal Oak when Blind Jack of Knaresborough played his fiddle there and Harrogate's first theatrical productions were held in the barn. It was renamed the Granby in 1795. Blind Jack allegedly eloped with the landlord's daughter on the eve of her wedding in the 1830s. Guests have included Laurence Sterne and Robert Clive of India. The Granby is now Granby Court Care Home, and is seen here in an engraving by J. Stubbs (1829).

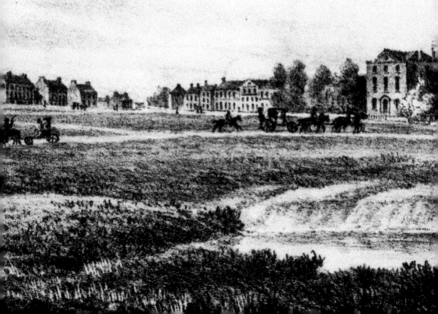

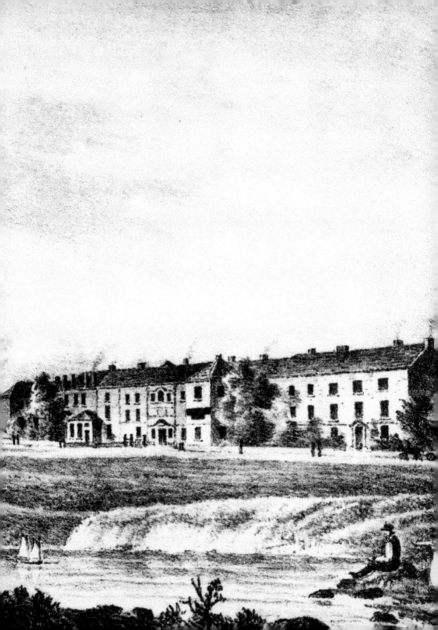

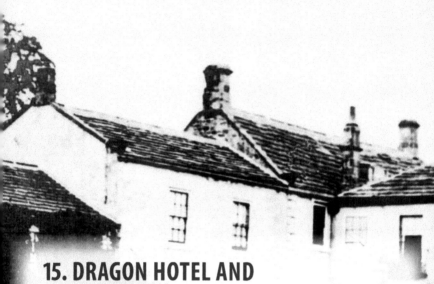

15. DRAGON HOTEL AND THE DUNMOW FITCH

First records of the Dragon (named after one of Charles II's racehorses) go back to 1764 when the owners, the Liddals, won the famous Dunmow Fitch, where married couples went to Dunmow, Essex, and swore that they had not quarrelled for a year and a day and never wished themselves not married. The hotel was also called the Green Dragon and was owned between 1827 and 1830 by Thomas Frith, father of the painter W. P. Frith. In 1870, it became High Harrogate College, and was demolished in the 1880s to make way for Mornington Crescent. Many of the hotels grew out of farmhouses; the popularity of the town as a spa rather took it by surprise and many visitors were initially accommodated in extended farmhouses, eating produce from the farms. The Dragon, Granby and Queen all were originally farms and all three are in High Harrogate, close to the St John and Tewit Wells.

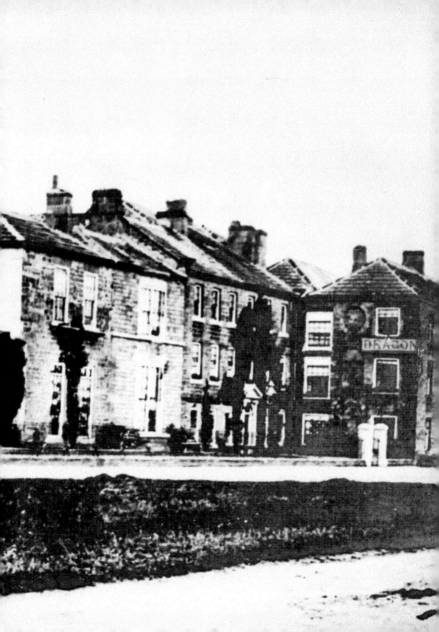

16. THE QUEEN HOTEL

The hotels soon acquired nicknames characteristic of their clientele. The Granby, popular with the aristocracy, was known as 'The House of Lords'; the Dragon was 'The House of Commons' due to its patronage by the military and the racier set; the Queen was frequented by tradesmen and merchants and was known as 'The Manchester Warehouse'. The Crown was known as 'The Hospital' because it was close to the Old Sulphur Well. The Queen was probably named after Charles II's wife, Catherine of Braganza; now the Cedar Court, it was reputedly Harrogate's first purpose-built hotel. Blind Jack was resident fiddler here around 1732. Like the Grand, the Queen was requisitioned by the Empire Pilot's Receiving Scheme during the Second World War. It became the headquarters for the regional health authority in 1950, but happily reverted to its intended use in 1990.

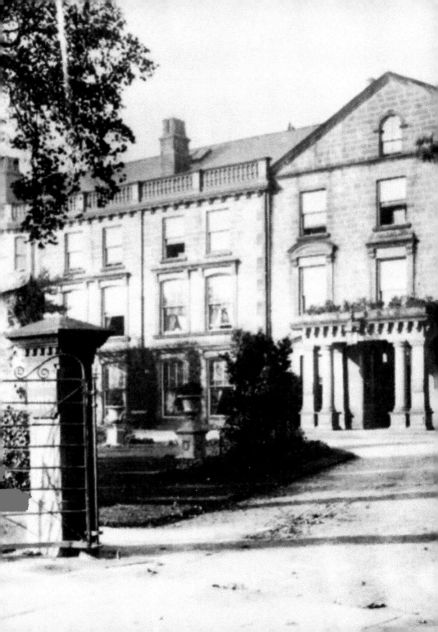

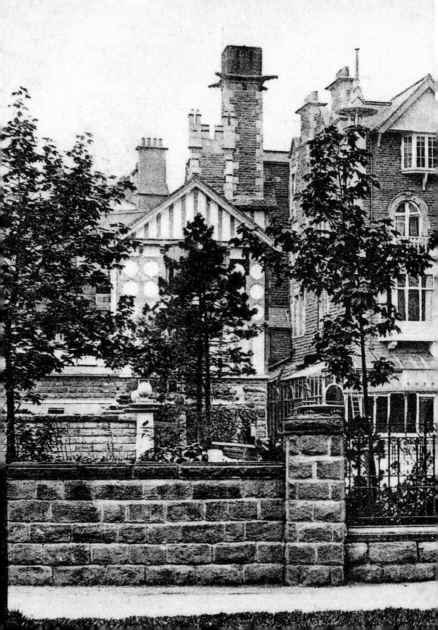

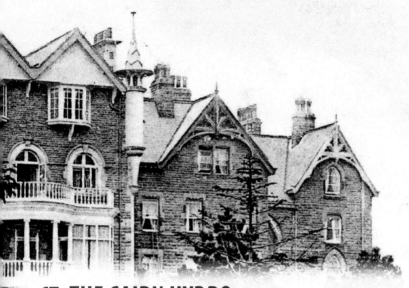

17. THE CAIRN HYDRO

Built in 1890, the hotel was renamed the Cairn Hotel. In 1896, £2 9*s*
to £3 10*s* got you bed, attendance, table d'hôte, breakfast, luncheon,
afternoon tea, a free bath every morning and a copy of the *Cairn
Times.* Evidence that the very early inns or hotels were somewhat low
rent comes from Lady Verney in a letter of 1665: 'We arrived att the
nasty Spaw, and have now began to drinke the horrid sulphur watter,
which allthowgh as bad as is poasable to be immajaned, yet in my
judgement plesent to all the doings we have within doorse. The House
and all that is in it being horridly nasty, and crowded up with all sorts
of company, which we eate with in a roome, as the spiders are ready
to drop into my mouth, and it sure hathe nethor been well cleaned nor
ared this dousen years; it makes me much more sicke than the nasty
watter.' It is unlikely that she ever went back.

18. THE SWAN

The Swan Inn was built around 1700 as the Old Swan and run by Jonathan Shutt, who began receiving visitors at 'the Sign of the Swan'. In 1820, it was rebuilt and named the Harrogate Hydropathic, reverting first to the Swan Hydropathic and then to the Swan Hotel in 1953. Originally modelled on Smedley's Hydro at Matlock, the Hydropathic had 200 bedrooms, each with a coal fire, and was the first in Harrogate to be lit by electricity. The first resident physician (and one of the directors) was a Dr Richard Veale. To make it fully compliant with its health objectives, the Hydro sacrificed its alcohol licence, banned smoking and made morning prayers compulsory.

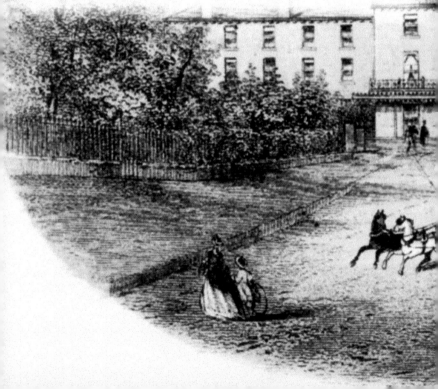

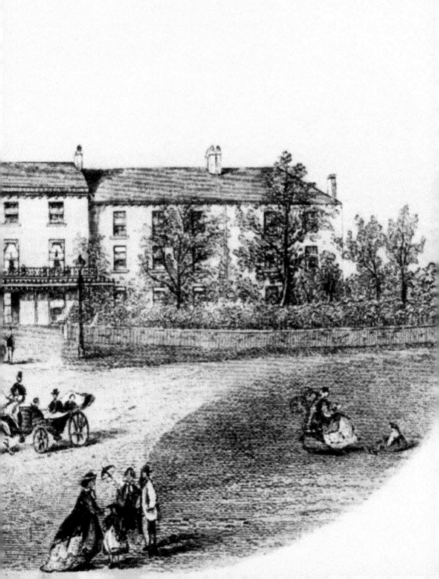

19. AGATHA CHRISTIE AND THE SWAN

In 1926 Agatha Christie took refuge here. She had left her home in Sunningdale, Berkshire, at around 9.45 p.m. on 3 December, abandoned her car precariously on the edge of a chalk pit and caught a train to Harrogate after seeing a railway poster advertising the resort. She checked in under the name of her husband's mistress, and so began the hotel's association with murder, mystery and suspense. Meanwhile, a nationwide search was underway, the first in the country to involve aeroplanes. After ten days, Bob Tappin, a banjo player at the hotel, recognised Mrs Christie and alerted the police. In 1979, the film *Agatha* was released, starring Vanessa Redgrave, Dustin Hoffman and Timothy Dalton, some of which was shot in the Swan and nearby.

DAILY SKETCH

INCORPORATING THE DAILY GRAPHIC

No. 5,518. Telephone { London—Museum 5181. Manchester—City 8581. } LONDON, WEDNESDAY, DECEMBER 15, 1926. { Registered as a Newspaper } ONE PENNY.

20 Pa
DAR
BLU
AGAI
ROUTH
AT
TWICKEN

MRS. AGATHA CHRISTIE FOUND ALIV

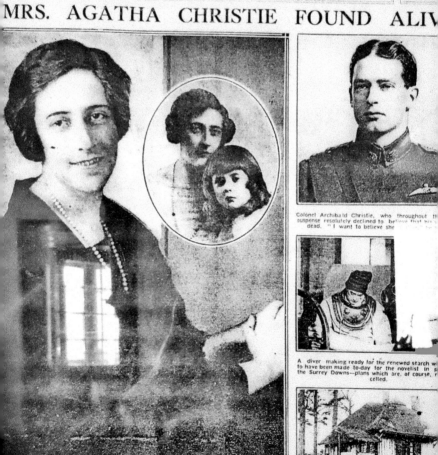

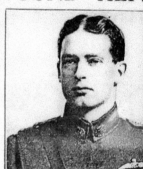

Colonel Archibald Christie, who throughout th suspense resolutely declined to believe that his dead. "I want to believe she

A diver making ready for the renewed search w to have been made to-day for the novelist in p the Surrey Downs—plans which are, of course, celled.

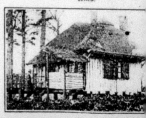

The lonely hut, near Newlands Corner, in whic

issing for eleven days, Mrs. Agatha Christie, the novelist, of whom this is one of the latest photographs, as found yesterday at Harrogate. Following on police information her husband, Colonel Christie, travelled rlier in the day to the Yorkshire resort from Sunningdale, from which Mrs. Christie disappeared on the ening of Friday, December 3. To-day a search of the Surrey Downs over an area of 40 square miles was have been made, and divers were to have descended pools and wells near Newlands Corner where the

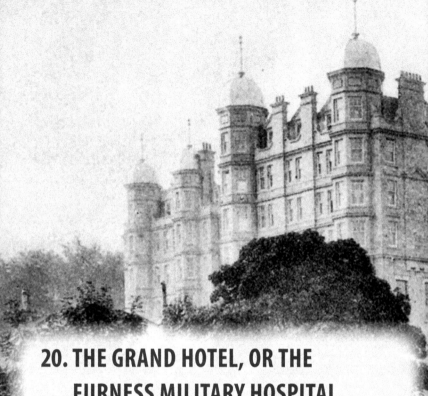

20. THE GRAND HOTEL, OR THE FURNESS MILITARY HOSPITAL

Opened in 1903 on Cornwall Road opposite the Sun Pavilion, the former Grand Hotel is now Windsor House and home to offices. During the First World War it was converted into the Furness Military Hospital. In common with other hotels in the town, it was also requisitioned by the Ministry of Defence during the Second World War for the Empire Pilot's Receiving Scheme. Unfortunately, after the war it struggled to re-establish itself as a hotel. The lounge was famous for its tapestries depicting old Harrogate and murals illustrating English spas. Conri-Tait and his band were the resident entertainment in the 1930s.

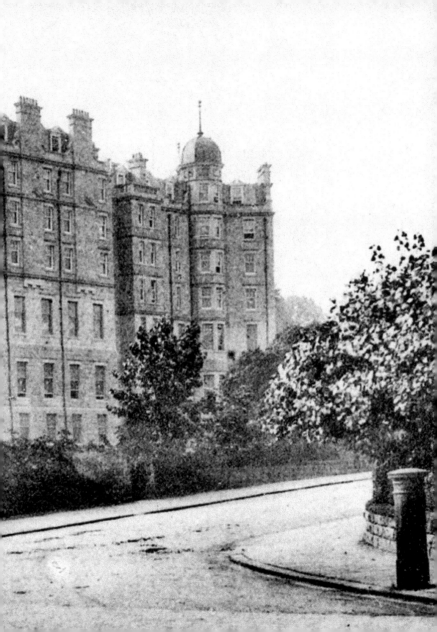

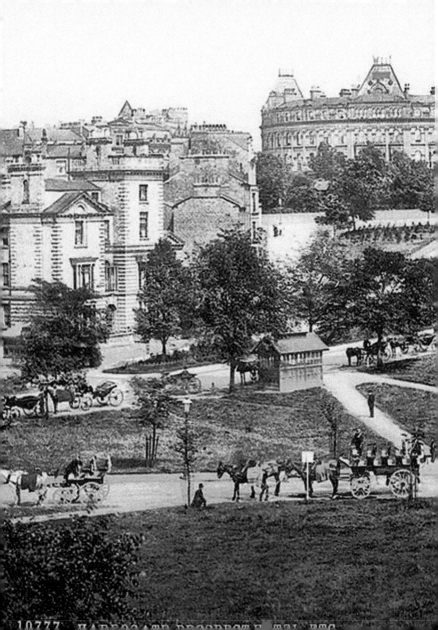

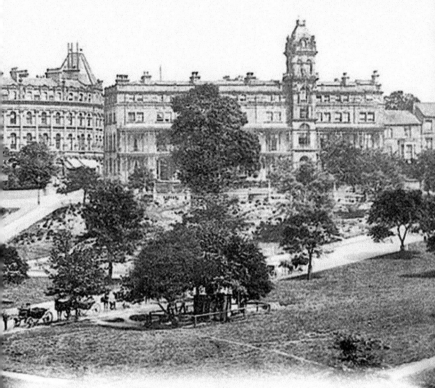

21. THE PROSPECT HOTEL

A rank of bath chairs outside the 1859 hotel: 1*s* 3*d* for the first hour and 4*d* for every quarter of an hour after that. Before the age of the bath chair, transportation was more basic: in 1660, the local constable claimed 7*d* for 'carrying one cripple to Harrogait on horseback'. In 1810, a journalist by the name of Henry Curling had waxed lyrical about the town: 'What scenes of life have we not beheld at Harrowgate. What days of romance and nights of revelry and excitement have we not passed ... where mothers trotted out their daughters in all their charms and country squires learnt the trick of wiving.'

22. HOTEL MAJESTIC AND SIR BLUNDELL MAPLE'S BILL

The Majestic's origins lie in a dispute between a local businessman, Sir Blundell Maple, and the Queen Hotel. On checking his bill one morning, Sir Blundell spotted an error. Not receiving satisfaction from the Queen's manager, he stormed out, threatening to build a hotel that would put the Queen out of business. And so was born the Majestic; although it was and is a fine hotel, it nevertheless failed to ruin the Queen. Guests included Edward Elgar, Winston Churchill, Errol Flynn and George Bernard Shaw.

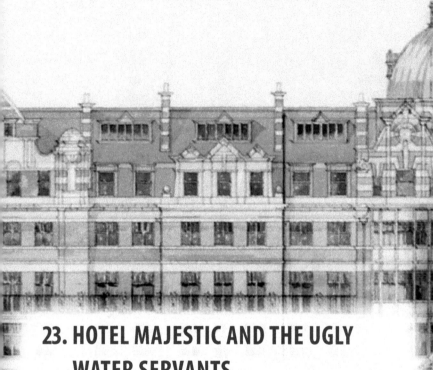

23. HOTEL MAJESTIC AND THE UGLY WATER SERVANTS

Thomas Baskerville (d. 1840), surgeon and botanist, speaks of his irritation at the over-eager water servants invading even hotel rooms to ladle out the water: '"I am pretty Betty, let me serve you" ... "Kate and Cozen Doll, do let we tend you ..." but to tell the truth they fell short of that for their faces shone like bacon rine. And for beauty may view with an old Bath guide's ass.' The photograph is of the original architect's plans for the hotel's south facade.

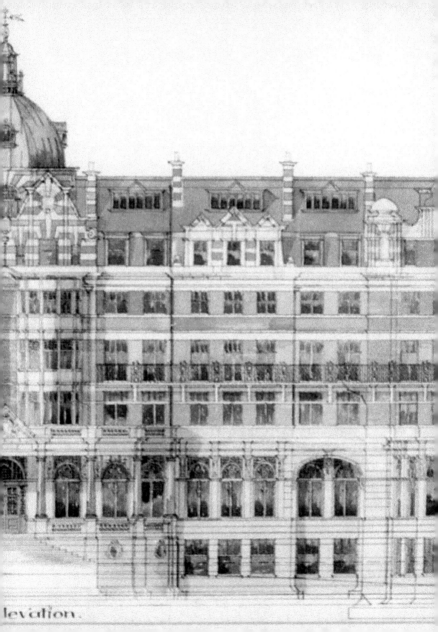

levation.

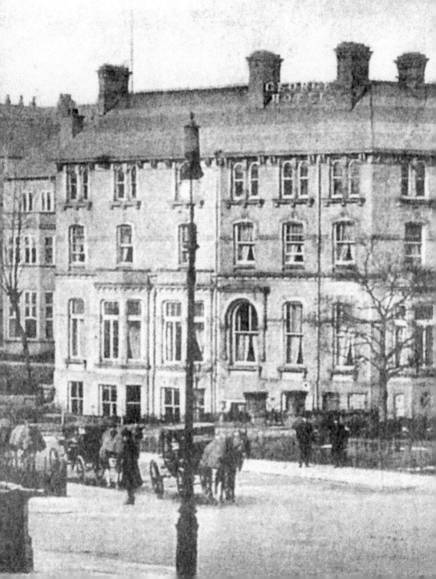

George Hotel

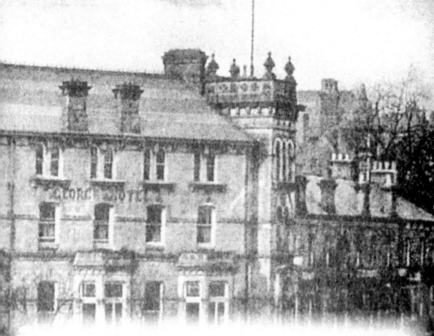

24. ST GEORGE HOTEL

The St George Hotel, opposite the Kursaal, developed slowly but surely from its origins as a small cottage. From 1778 it began to offer the services of an inn. On 9 May 1910, Princess Victoria, the king's sister, and the Grand Duchess George of Russia watched from a window as George V was proclaimed king and emperor on the steps of the Royal Baths. Other 1930s' Harrogate accommodation included the Harrogate Food Reform Guest House in St Ronan's Road where 'dieting is understood', while Miss Hamilton, at the Octagon Boarding House, ensures a 'liberal table'.

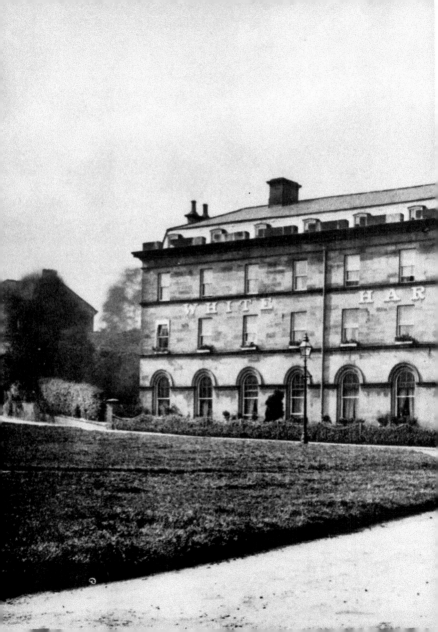

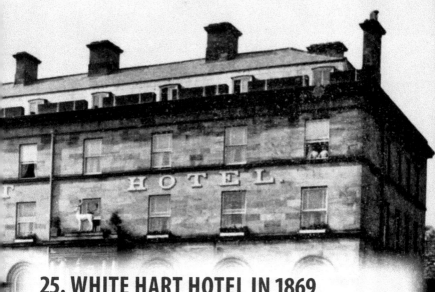

25. WHITE HART HOTEL IN 1869

Built in 1846, this neoclassical building is, in Pevsner's estimation, 'easily the best building in Harrogate … with nothing gaudy or showy about it'. Tobias Smollett stayed in the town in 1766 and describes his time here in *Humphrey Clinker*: Harrogate was 'a wild common, bare and bleak, without tree or shrub or the least signs of cultivation'. Charles Dickens visited the Spa Rooms to deliver some readings in 1858 and said, 'Harrogate is the queerest place with the strangest people in it, leading the oddest lives of dancing, newspaper reading and tables d'hôte.' The Jarrow Crusaders paused here on the Stray to the front of the hotel in 1936.

26. THE CROWN

Built originally in 1740 by Joseph Thackwray, great-uncle of the owner of Montpellier Square and Gardens, The Crown was renovated in 1847 and again in 1870. Thackwray was given permission to buy the Crown by George III in 1778. In 1784, the head waiter, William Thackwray, was making so much money that he was able to buy the Queen Hotel. Thackwray was no fool: in 1822 he discovered a number of new wells, one of which was a sulphur well called the Crown Well, and another he channelled into the backyard of the Crown.

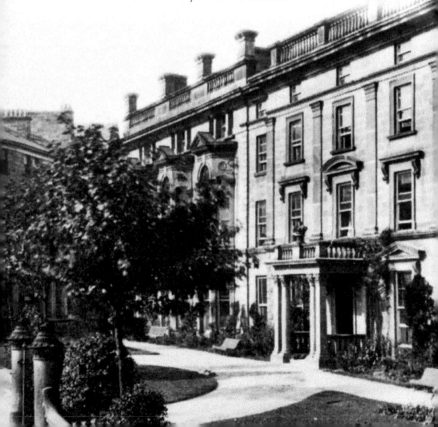

27. LORD BYRON, THE CROWN AND THE QUAKER GIRL

An early photograph of around 1865 shows a meet outside the Crown. Lord Byron stayed in 1806 with 'a string of horses, dogs and mistresses'. Whilst here he wrote 'To a Beautiful Quaker' inspired, it seems, when he happened to notice a pretty Quaker girl. Elgar visited in 1912. During the Second World War, the Government requisitioned the Crown for the Air Ministry – they finally vacated in 1959.

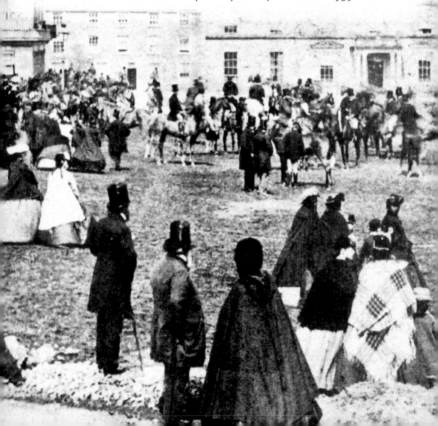

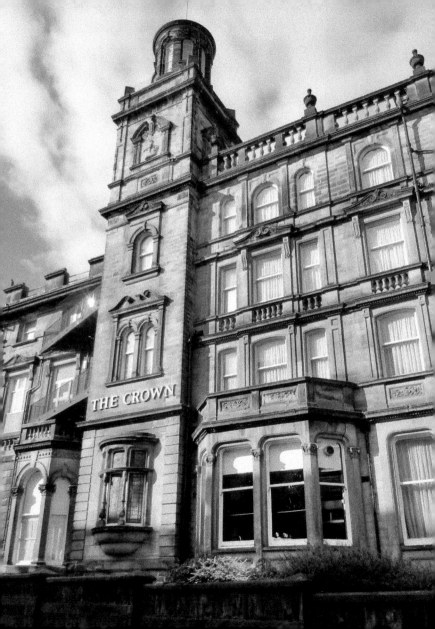

THE CROWN

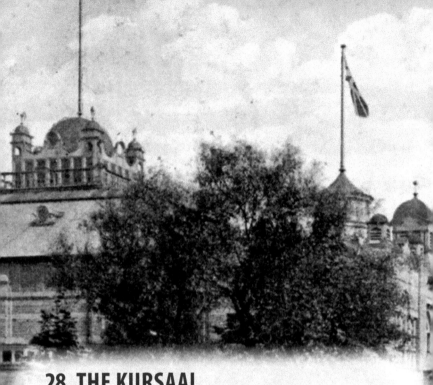

28. THE KURSAAL

Loosely modelled on Ostende Kursaal in Belgium, the Kursaal was opened in May 1903 by Sir Hubert Parry (of 'Jerusalem' and 'I Was Glad' fame) on the site of Bown's 1870 Cheltenham Pump Room. Early attractions included Sarah Bernhardt, the Halle Orchestra, Pavlova and Dame Nellie Melba. The name Kursaal (Cure Hall) comes from the buildings so named and popular in continental spa towns. In Harrogate, the name was changed in 1918 to the less Germanic Royal Hall and boasted 1,276 seats. The Kursaal came about as a response to the growing demand for entertainment in Harrogate and, because at the time the popularity of Chloride of Water was declining, the pump room was demolished to make way for it.

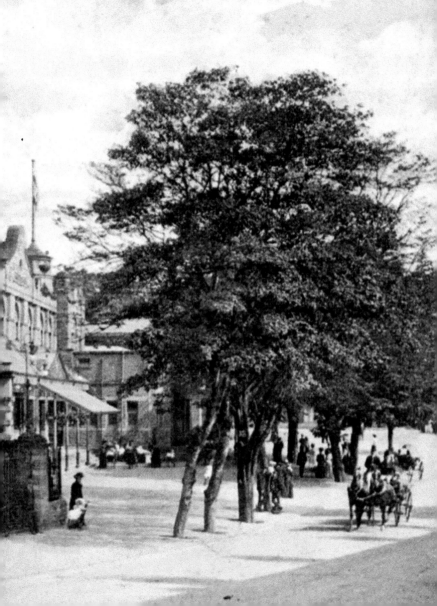

40478. HARROGATE: KURSAAL.

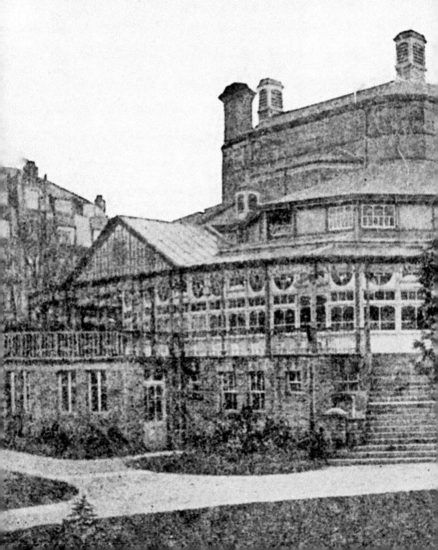

The Kursaal, Harrogate, wherein is situated the Soldiers' Club.

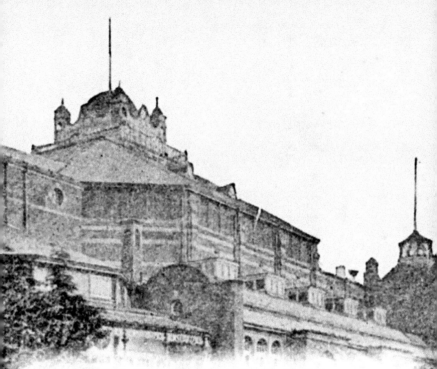

29. ROYAL HALL SOLDIERS CLUB

The breathtaking Royal Hall is now an integral part of Harrogate International Conference Centre. It opened in 1981 and was the result of a decision in the 1960s to keep Harrogate on the world stage, and thus ensure its economic survival. By using the buildings and services that had catered for the town as a spa, Harrogate turned into a conference and exhibition venue of considerable importance. In 1959, a temporary hall was set up in the Spa Rooms and Gardens and the town was able to accommodate the prestigious toy fair a few years later. Today, over 2,000 events take place in the centre each year, bringing in nearly £200 million.

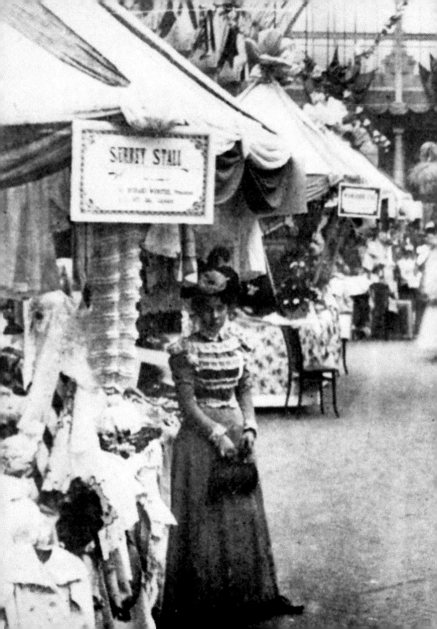

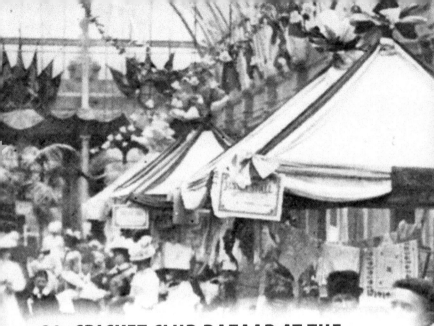

30. CRICKET CLUB BAZAAR AT THE WINTER GARDENS

John Feltham's 1804 *Guide to All the Watering and Sea-Bathing Places* tells us how Harrogate society worked and notes the practice of men and women remaining in the same room after dinner, whereby 'the ladies, by this custom, have an opportunity of witnessing the behaviour of gentlemen; and the latter of determining how well qualified the former may be for presiding over a family.' On entertainment generally: 'Deep play, of any kind, is seldom practiced at Harrowgate; the person who could renounce female society, which is here to be had without difficulty, for a pack of cards, or a faro bank, would be generally avoided. Another advantage of mixing freely with the ladies, is the sobriety it ensures; to which the waters, indeed, contribute not a little.'

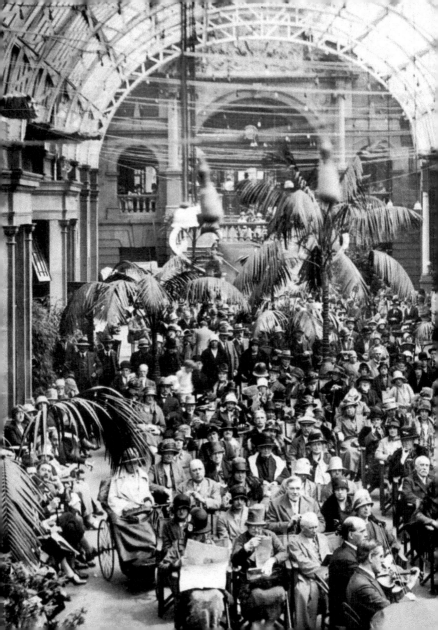

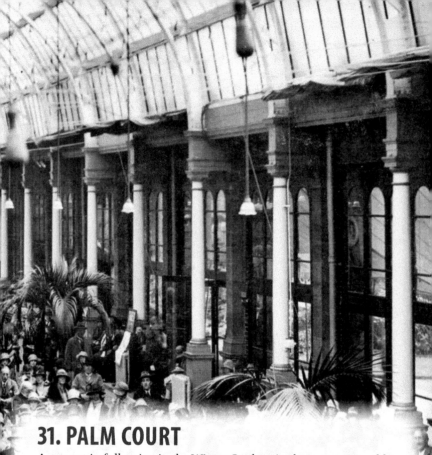

31. PALM COURT

A concert in full swing in the Winter Gardens in the 1920s – possibly
Cecil Moon's Palm Court Trio. It certainly was popular, with standing
room only, but not everyone was transfixed: take a look at the two
ladies and gentlemen at the front on the left, ensconced in their
newspapers and books. The Gardens were opened in 1897 and
demolished in 1936 when the Lounge Hall and Fountain Court were
built to replace them. All that remains are the original stone entrance
foyer and staircase.

32. CHELTENHAM SPA ROOMS

A magnificent 1835 classical building with superb Doric columns, the Spa Rooms were constructed to complement the Cheltenham Spring, so called because the waters were considered similar to those in Cheltenham. This had been discovered in 1818 and was soon regarded as the best Chloride of Iron spring in Europe. Increasing demand led to the building of a new pump room in 1871, by Bown, in the style of a miniature Crystal Palace. The building later became known as the Royal Spa Concert Rooms. The 6 acres of gardens featured a boating lake and skating rink with a pump room and colonnade, built in 1870. The Corporation bought the Rooms in 1896 and demolished the lot in 1939. However, the pillars survive and can be seen at RHS Harlow Carr.

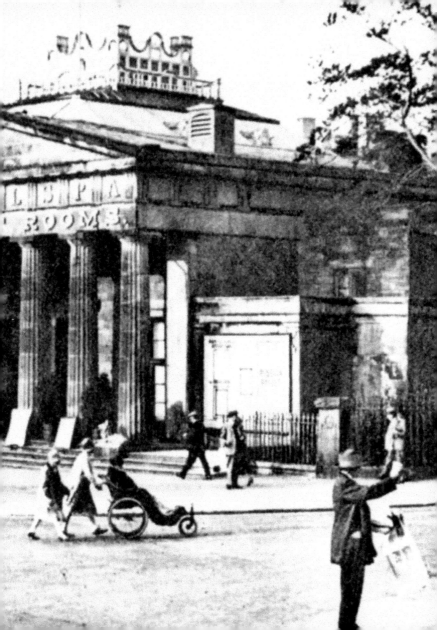

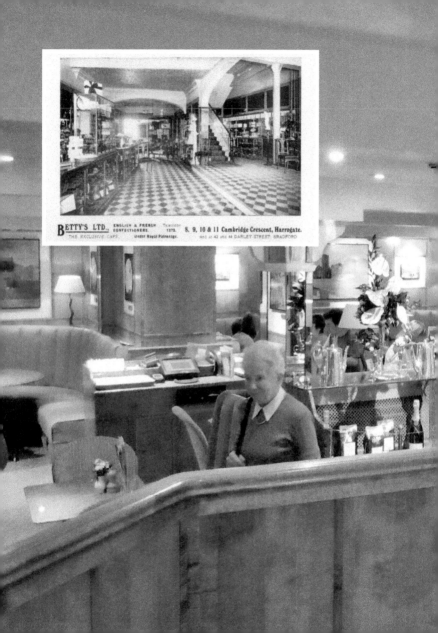

BETTY'S LTD., ENGLISH & FRENCH CONFECTIONERS. Telephone 1173. 8, 9, 10 & 11 Cambridge Crescent, Harrogate.
THE EXCLUSIVE CAFE. Under Royal Patronage. And at 42 and 44 DARLEY STREET, BRADFORD.

33. BETTY'S IN CAMBRIDGE CRESCENT

Frederick Belmont opened his first business in July 1919 – a café in Cambridge Crescent, on three floors, fitted out to the highest standards, 'furnished in grey, with muted pink panels with old-silver borders [and] candleholders'. The china was grey-blue; the tea and coffee pots heavy nickel silver. Takings for the first day were £30, with £220 for the first week. In 1920, he opened a second café and takings for the year were £17,000. Customers included Lady Haigh, Lord Jellicoe, the Duke of Athlone and Princess Victoria.

34. BETTY'S IN THE VALLEY GARDENS

A pleasant afternoon taking tea in the Valley Gardens at the Tea House, run by Taylors. Taylors also handled the catering at the Winter Gardens and at the Royal Spa Concert Rooms. Charles Edward Taylor, a Quaker and son of a York master grocer, set up the business with 'Kiosk' tea and coffee shops in fashionable Harrogate (at No. 11 Parliament Street) and Ilkley after an apprenticeship at James Ashby, the London tea dealers. His time there had taught him just how crucial the local water was to particular blends of tea – a lesson well learnt and relevant to this day in the form of Taylors specially blended Yorkshire Tea. The kiosks were followed by Café Imperials in both towns – the Ilkley branch opened in 1896 and the Harrogate branch in 1905, in the mock Scottish castle now occupied by Bettys. The Ilkley Bettys is the old Taylors 'Kiosk' Café and Little Bettys in York occupies the former Taylors 'Kiosk' café. In 1962 Bettys acquired Taylors. Their slogan was 'They came to take our waters; they much prefer our tea.'

VALLEY GARDENS, HARROGATE.

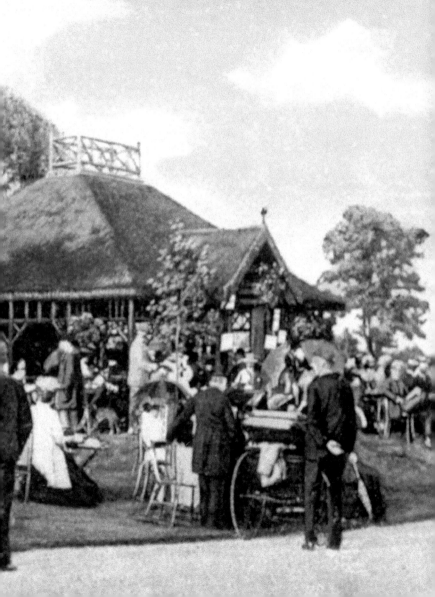

35. FARRAH'S

Founded in 1840 by John Farrah, the shop was originally on Royal Parade but closed in the mid-1990s and now stands on Montpellier Parade. The aim of Original Harrogate Toffee was to cleanse the palate of the putrid taste of Harrogate's sulphur water. Original Harrogate Toffee is similar to both butterscotch and barley sugar and uses three different types of sugar, butter and lemon to give a unique texture and flavour. It is still made in copper pans and packaged in the recognisable trademark blue-and-silver embossed tins.

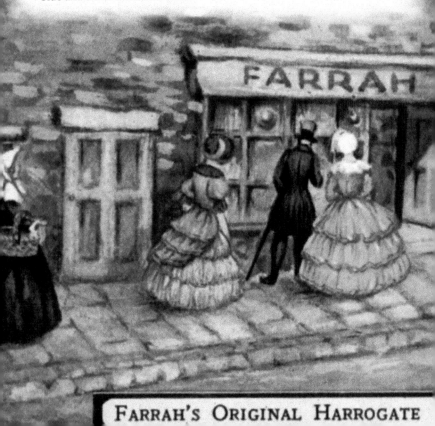

FARRAH'S ORIGINAL HARROGATE

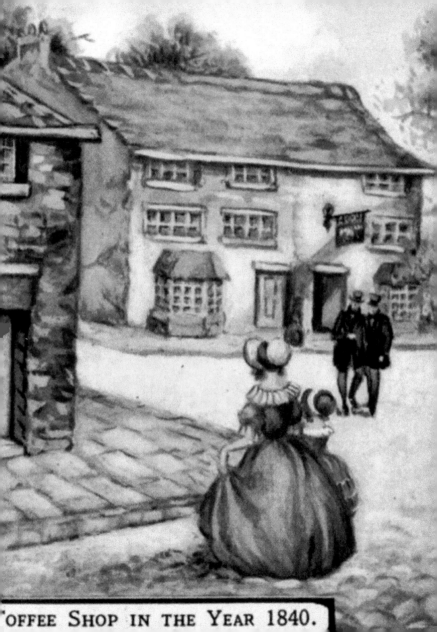

COFFEE SHOP IN THE YEAR 1840.

36. OGDEN'S AND THE TOMB OF TUTANKHAMUN

In 1893, James Roberts Ogden opened the Little Diamond Shop in Cambridge Street, the genesis of what was to become one of Britain's most famous and prestigious jewellers. The impressive Edwardian shopfront and showrooms in the current James Street shop, bought in 1910, still retain many of the original Edwardian features. Down the years, Ogden's has supplied jewellery and silverware to royalty and heads of state, including Eleanor Roosevelt, George VI and Princess Marina. Sir Winston Churchill had a silver cigar case made by Ogden's. J. R. Ogden was a celebrated Egyptologist and was adviser to Howard Carter and Sir Leonard Woolley. Carter, of course, went on to discover the tomb of Tutankhamun in 1922. J. R. Ogden was also advising goldsmith to the British Museum and was involved in the restoration of some of the most precious gold artefacts that can now be found in museums around the world. The company is currently run by the fourth and fifth generations of the family.

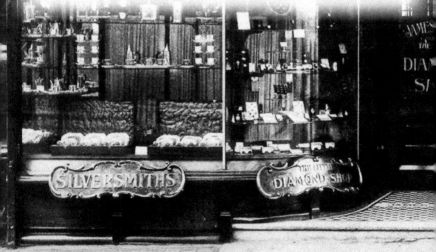

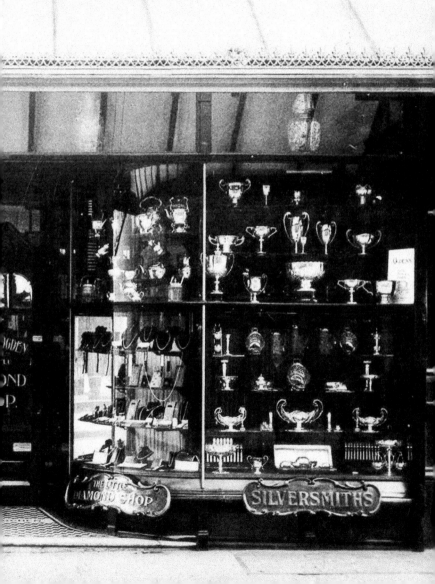

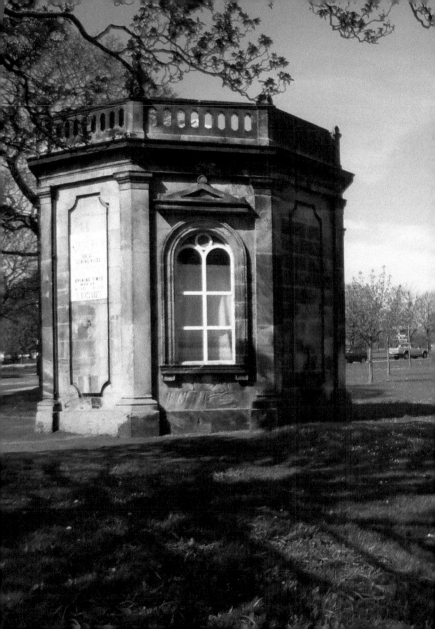

37. HIGH HARROGATE

The inset image shows one of a series of fine prints of Harrogate scenes sold by the bookseller, printer and stationer T. Hollins of No. 26 Park Parade. The prints were made in 1853 by Rock and Co., London. The 1831 Christ Church (formerly St John's Chapel) is in the background. Before 1800, High Harrogate was Harrogate; Low Harrogate (or Sulphur Wells as it was originally called) was only just beginning to show its potential due to the Old Sulphur Well. But it was to High Harrogate that people initially came, well accommodated by the Granby, Queen and Dragon hotels. These hotels succeeded boarding houses and, before that, farmsteads, where early visitors for the cure stayed – with bath tubs and casks of water from the wells brought in by maids.

38. THE STRAY

The Stray came about after the punitive 1770 Acts of Enclosure with the Duchy of Lancaster Commissioners' great award of 1778. This ensured that 200 acres of land linking the wells would remain open, thus protecting public access to the springs and allowing space for people to exercise in – exercise was just as important a factor in the cure as the waters. In addition, the land was used for concerts and accommodated a racecourse for a while from 1793. Eli Hargrove opened a subscription library nearby in around 1775. For Queen Victoria's Golden Jubilee in 1887, a huge barbecue was held on the Stray; the people of Harrogate roasted an ox for twenty-four hours, ate 4,000 buns and drank 500 gallons of beer. During the war, trenches were dug to prevent enemy planes from landing there.

HARROGATE – THE STRAY. (No 3)

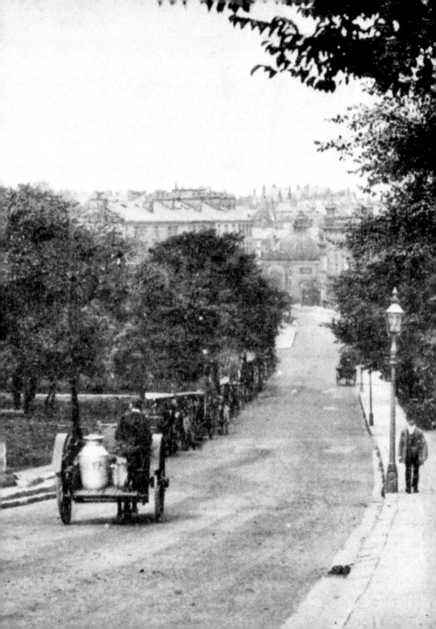

39. STATION SQUARE AND THE BARREN COWS

Much of this was demolished to make way for the Victoria Gardens Centre. The Queen Victoria Jubilee Monument was erected in 1887 by Mayor Richard Ellis to mark the queen's Golden Jubilee. This was all part of the Victoria Park Company scheme to develop a new town centre linking the two Harrogates with residential and retail streets. The railway arrived in Harrogate in 1848 and the new station opened in 1862, bringing trainloads of tourists and thus heralding the start of Harrogate's tourist industry. However, not everyone was enthusiastic; it was thought by some that the trains would bring the 'lower orders' to the town and reduce the milk yield from local cows.

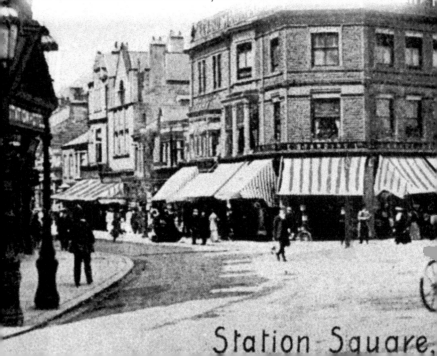

Station Square

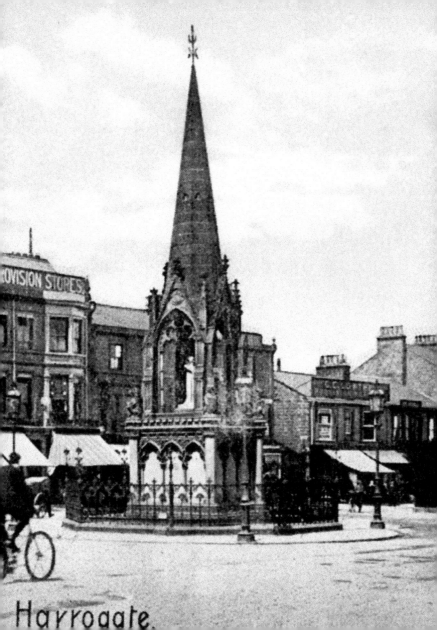

OVISION STORES

Harrogate.

40. PROSPECT PLACE AND THE PROSPECT HOTEL

Originally a private house, built in 1814 by Nicholas Carter Snr, the building gradually developed into a hotel as the owner took on more and more guests during the season. After a series of reconstructions, the hotel, then named the Prospect, had doubled in size by 1870 and sported its 82-foot tower. The fine ironwork on the facade was removed in 1936. Today it is the Yorkshire Hotel.

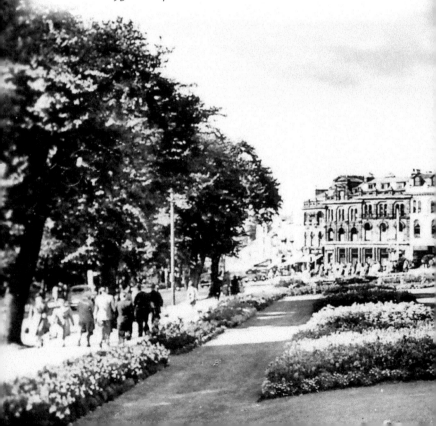

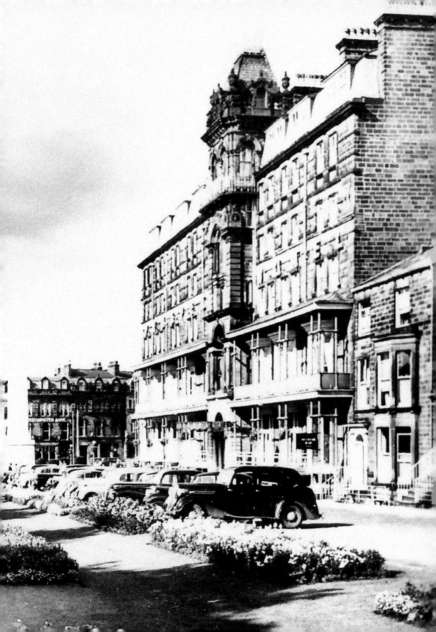

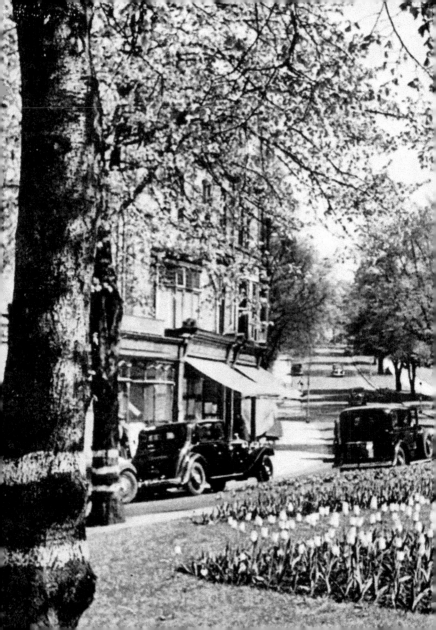

41. MONTPELLIER PARADE AND GARDENS

Much of these gardens were built in the 1860s by Harrogate builder George Dawson, adjacent to Thackwray's Montpellier gardens of the same name. Thackwray tried to divert the waters of the Old Sulphur Well to the backyard of the Crown by sinking a well there. This led to an Act of Parliament giving Harrogate powers to protect their mineral waters against such piracy.

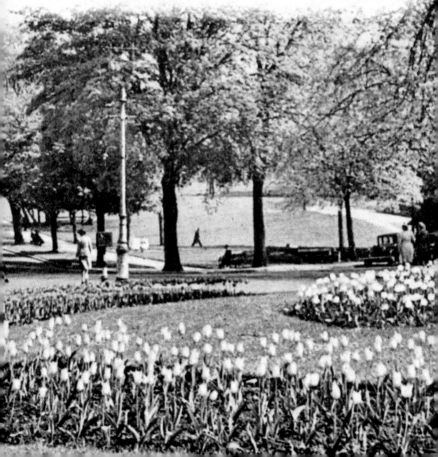

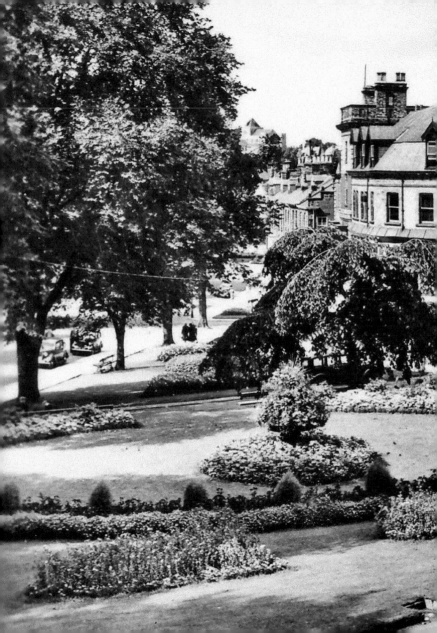

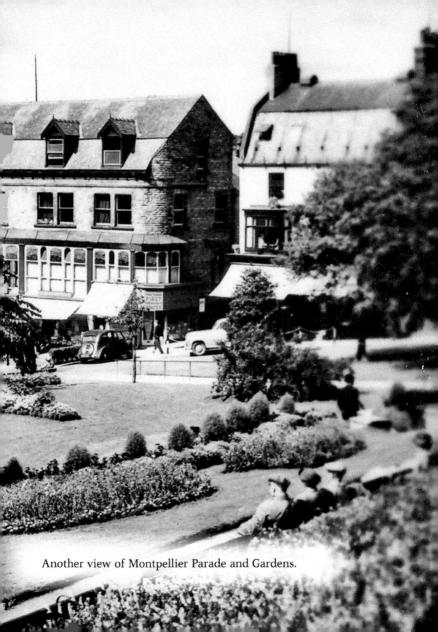

Another view of Montpellier Parade and Gardens.

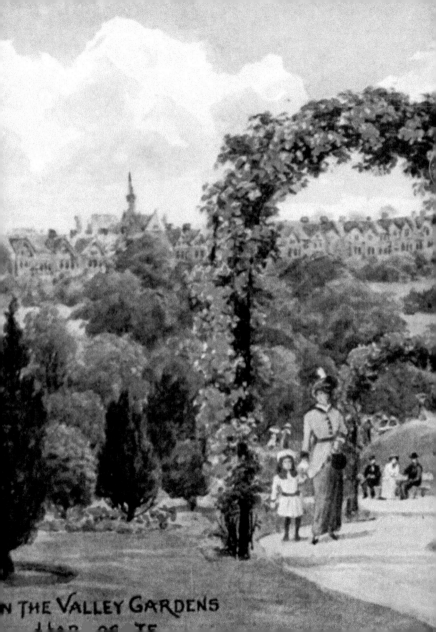

N THE VALLEY GARDENS

42. VALLEY GARDENS

Thirty-six springs rise within one acre of the Valley Gardens (there are eighty-nine in the town as a whole and each one is chemically different) all pumped down to the Royal Baths. The gardens were enlarged in 1901 to what is more or less their current layout. The central part was originally called Bog Fields after the boggy area that used to be there. The metal covers with their unique numbers, indicating the presence of a spring or well beneath, have long been removed in the interests of the efficiencies required for grass cutting.

Also Available from Amberley Publishing

This fascinating selection of photographs and lesser-known
stories details the history of Knaresborough.

Paperback
Around 100 illustrations
96 pages
978-1-4456-4340-3

Available from all good bookshops or to order direct
please call **01453-847-800**
www.amberley-books.com